LETTERING THE Gospel

BEGINNER & INTERMEDIATE CHRISTIAN LETTERING PRACTICE & PROJECTS

INSPIRED to Grace

Welcome to Lettering the Gospel!

THIS BOOK HAS 42 UNIQUE AND CREATIVE LETTERING PROJECTS FOR YOU TO ENJOY. THE PROJECTS VARY IN COMPLEXITY FROM BEGINNER TO INTERMEDIATE. WE RECOMMEND THAT YOU FLIP THROUGH THE BOOK UNTIL YOU SEE A VERSE OR A STYLE THAT SPEAKS TO YOU, AND START THERE. THERE IS NO RIGHT OR WRONG WAY TO ENJOY THIS BOOK.

LETTERING THE GOSPEL IS PRINTED ON 60-POUND BRIGHT WHITE STOCK WHICH ALLOWS US TO PROVIDE AN EXCELLENT VALUE TO OUR CUSTOMERS. IF YOU HAVE ISSUES WITH BLEEDING, OR IF YOU MAKE A MISTAKE AND WANT TO START OVER, YOUR PURCHASE INCLUDES A DOWNLOAD CODE WHICH WILL ALLOW YOU TO SIGN UP FOR OUR NEWSLETTER AND THEREBY ACCESS ALL THE LETTERING PROJECTS IN THIS BOOK AS PDF DOWNLOADS.

SIGN UP AT: WWW.INSPIREDTOGRACE.COM/LTG

YOUR DOWNLOAD CODE: **LTG3623**

@inspiredtograce

Inspired to Grace

GO INTO ALL THE WORLD

&

PREACH

the

GOOD

NEWS

TO

EVERYONE

Mark 16:15

UPON THIS Rock I WILL BUILD MY CHURCH MATTHEW 16:18

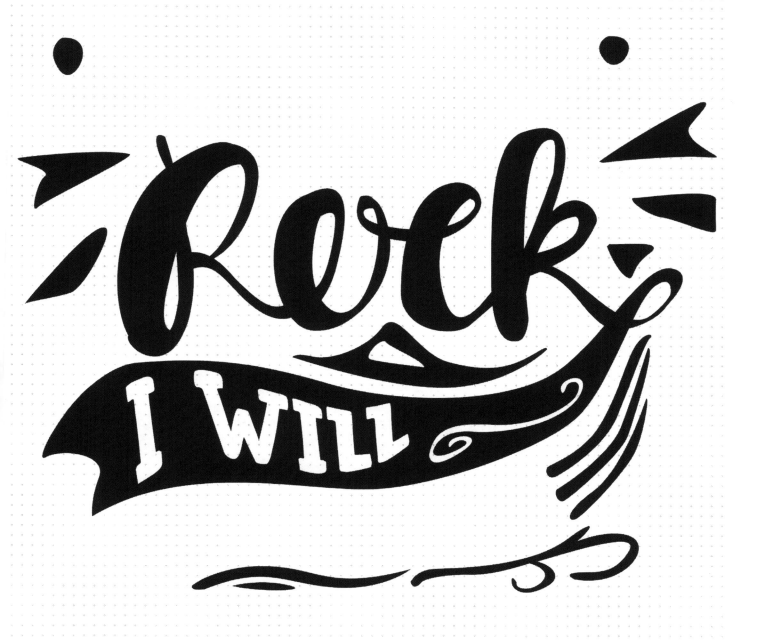

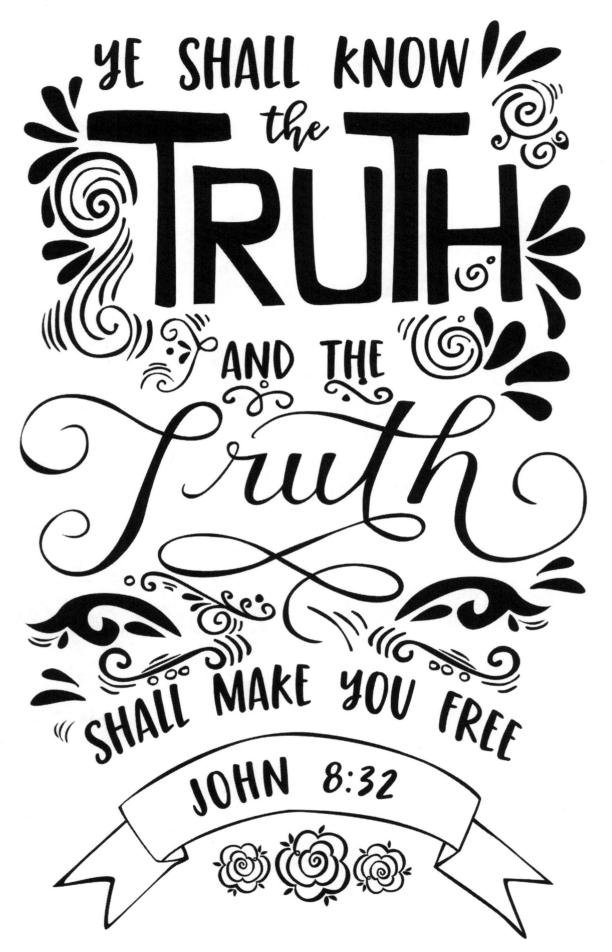

A new command I give you: Love ONE another as I have Loved YOU, so you must Love ONE another

JOHN 13:34

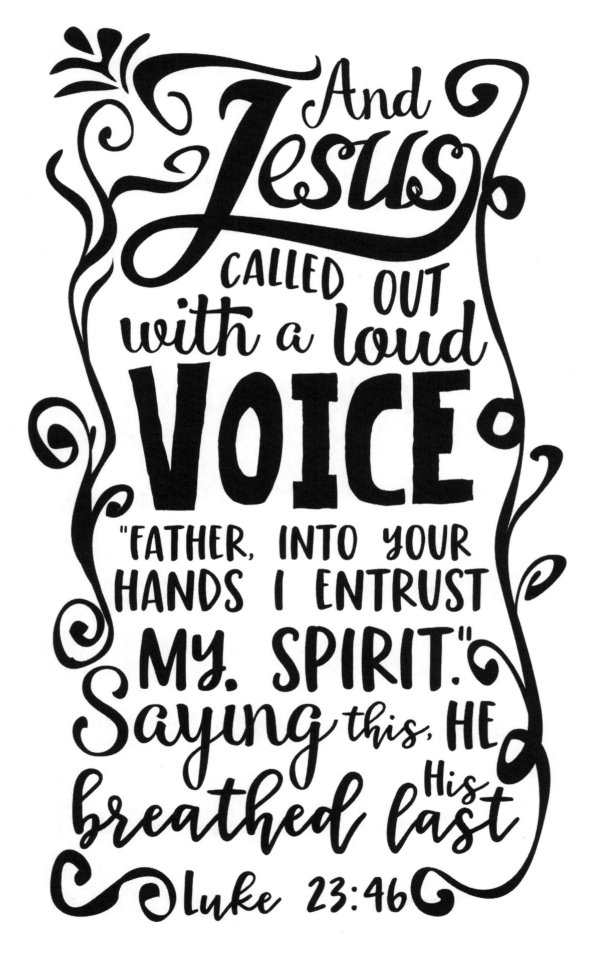

And Jesus CALLED OUT with a loud VOICE "FATHER, INTO YOUR HANDS I ENTRUST MY. SPIRIT." Saying this, HE breathed His last Luke 23:46

LETTERING PROJECT 5

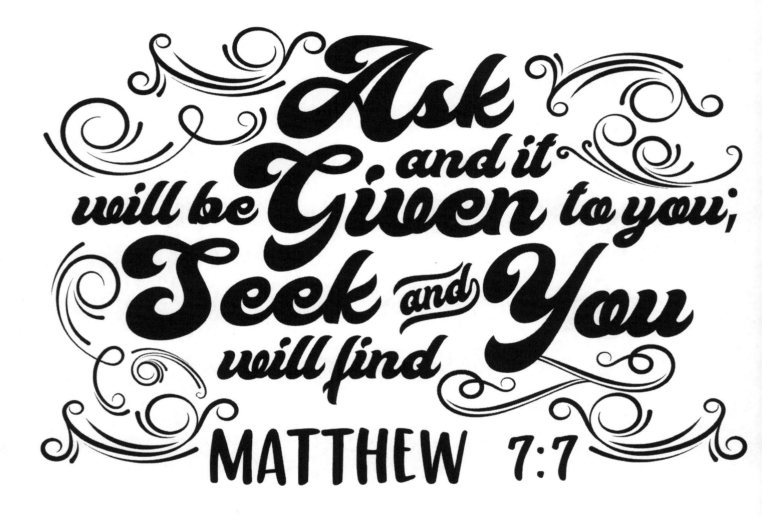

Ask and it will be Given to you; Seek and You will find

MATTHEW 7:7

Behold, I send YOU out as sheep IN THE MIDST of wolves. THEREFORE BE wise as SERPENTS & harmless as DOVES MATTHEW 10:16

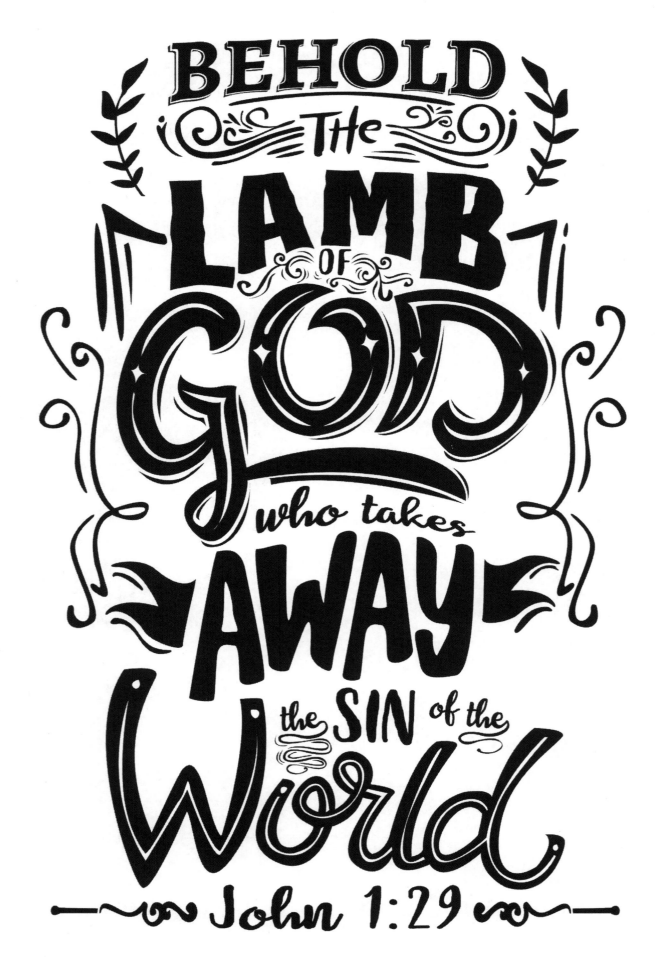

BEHOLD
THE
LAMB
OF
GOD
who takes
AWAY
the SIN of the
World
John 1:29

LETTERING PROJECT 8

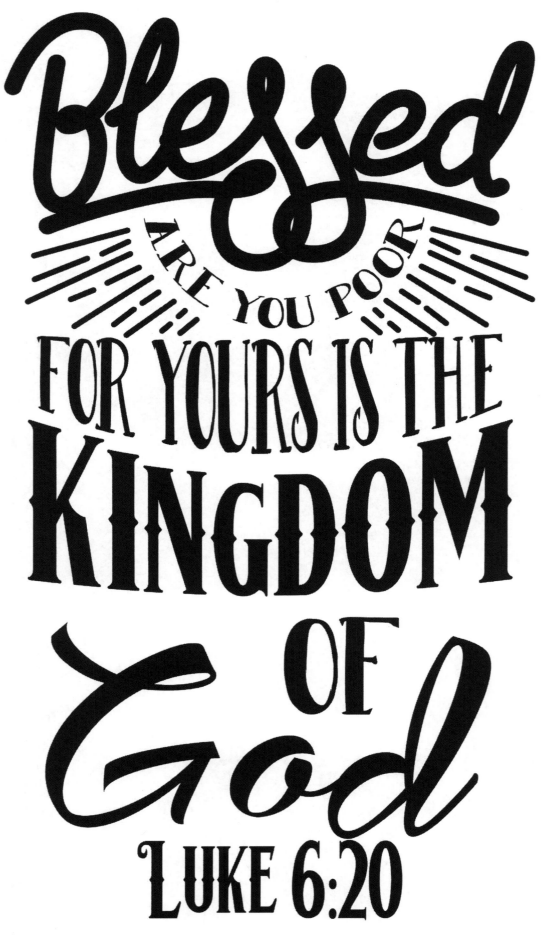

Blessed
ARE YOU POOR
FOR YOURS IS THE
KINGDOM
OF
God
LUKE 6:20

but seek first THE Kingdom OF God AND HIS righteousness

MATTHEW 6:33

Come to me,
ALL
you who
LABOR
AND are
BURDENED
AND I WILL
give you rest
MATTHEW 11:28

Do not let
YOUR hearts BE
TROUBLED
you have Faith
in GOD
Have
Faith
also
in me

~ JOHN 14:1 ~

DO NOT STORE UP

for

yourselves

Treasures

on Earth,

WHERE MOTH AND RUST

consume

MATTHEW 6:19

DO NOT TEST

The

LORD

YOUR

GOD

MATTHEW 4:7

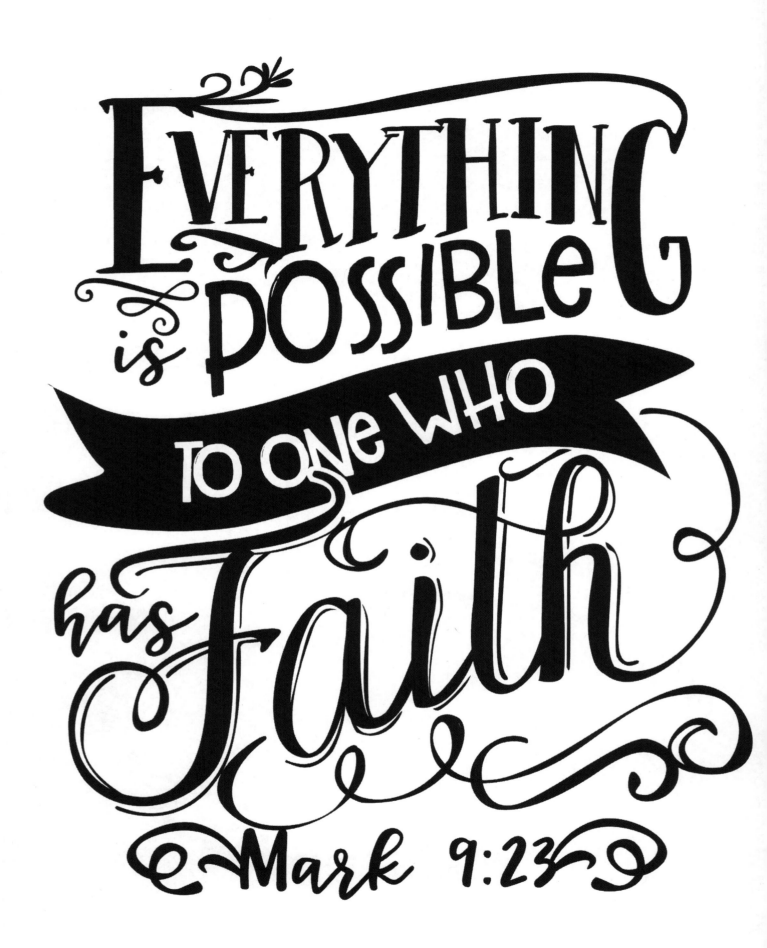

Everything is possible to one who has Faith Mark 9:23

TO ONE WHO

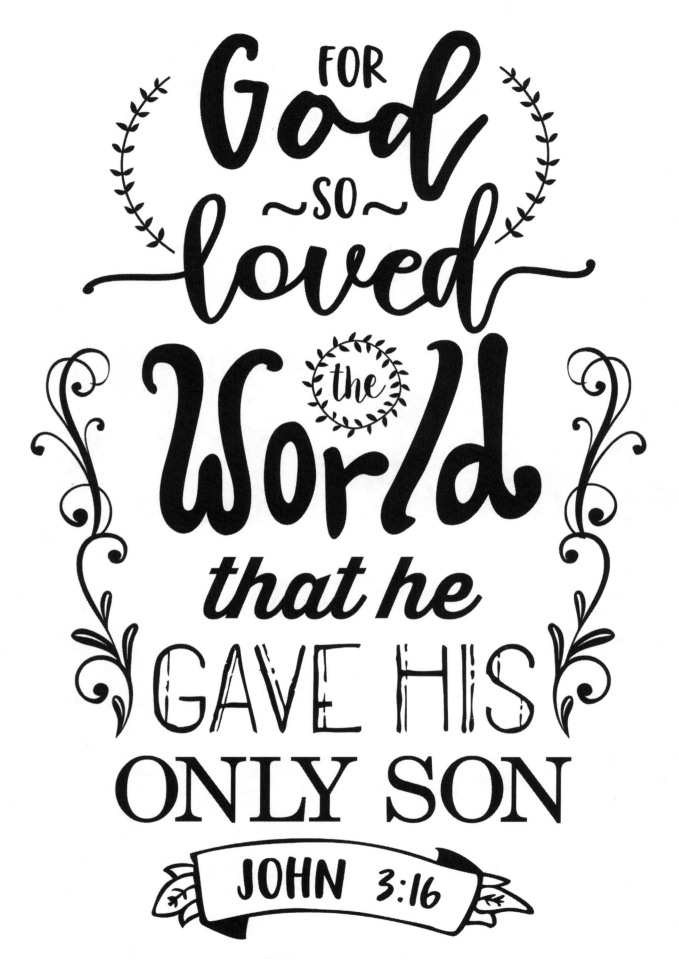

FOR God ~SO~ loved the World that he GAVE HIS ONLY SON

JOHN 3:16

LETTERING PROJECT 16

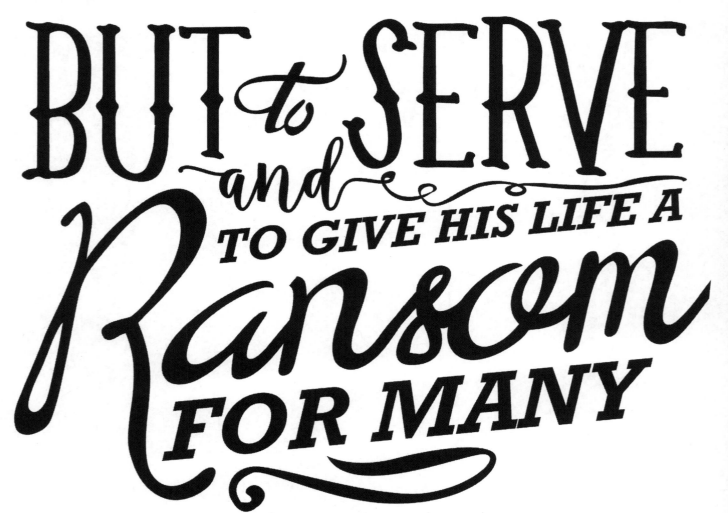

For even the SON OF MAN DID NOT COME TO BE SERVED BUT to SERVE and TO GIVE HIS LIFE A Ransom FOR MANY

MARK 10:45

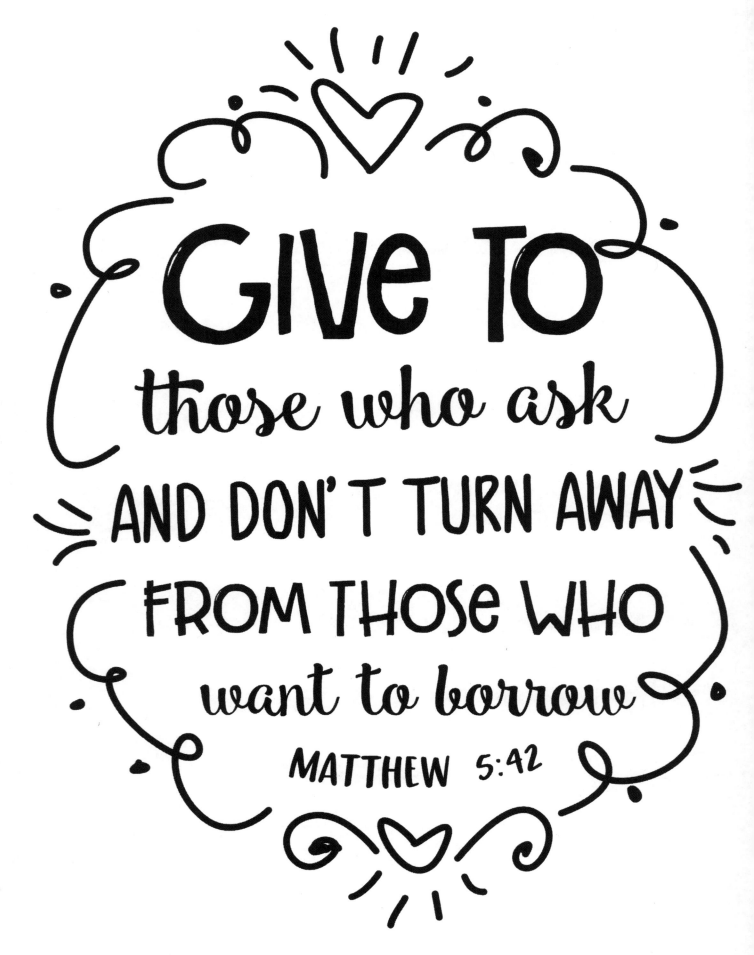

GIVE TO
those who ask
AND DON'T TURN AWAY
FROM THOSE WHO
want to borrow
MATTHEW 5:42

HE CAME AS A WITNESS

TO TESTIFY

TO THE LIGHT,

SO THAT

all might

BELIEVE

THROUGH HIM

JOHN 1:7

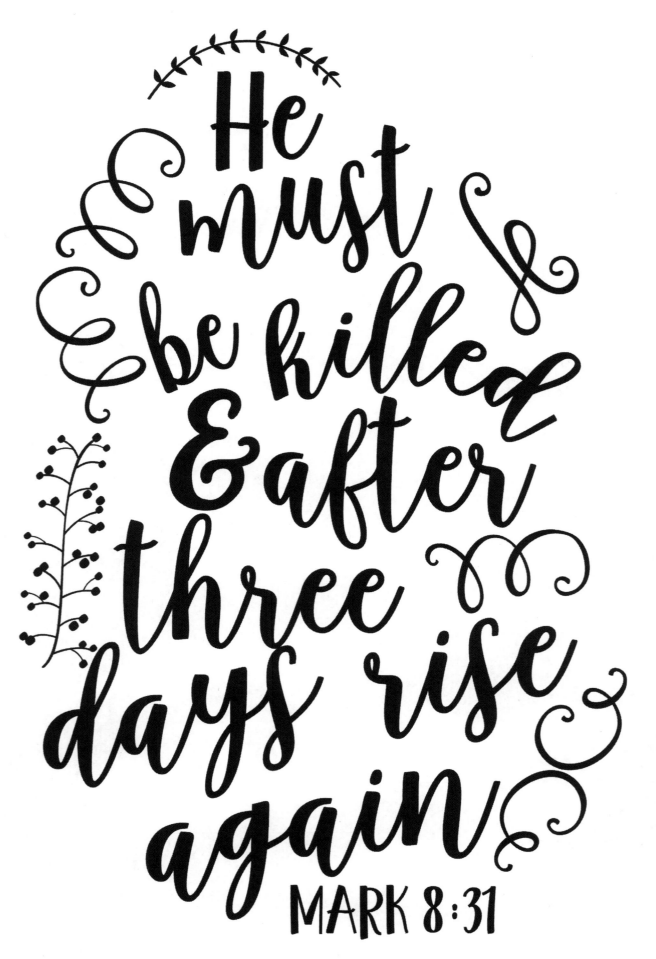

He must be killed & after three days rise again

MARK 8:31

IF YOU LOVE ME, YOU WILL KEEP my COMMANDMENTS

JOHN 14:15

in the BEGINNING was the Word AND THE WORD WAS WITH GOD, and the WORD was GOD

JOHN 1:1

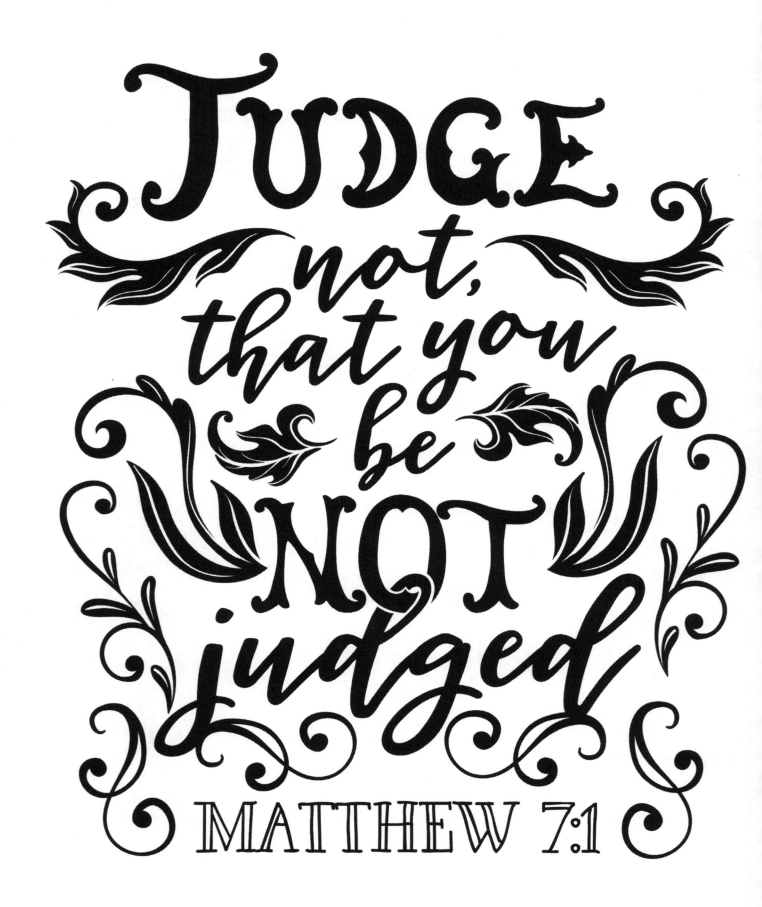

Let the
Little
CHILDREN
come
to Me
MARK 10:14

Look at my hands and my feet. It is I myself! Touch me and see; a ghost does not have flesh and bones, as you see I have

LUKE 24:39

Love the Lord your God with all your heart, all your SOUL, all your Mind, and all your STRENGTH

Mark 12:30

LETTERING PROJECT 26

LOVE YOUR ENEMIES

DO GOOD TO THOSE WHO HATE YOU BLESS THOSE WHO CURSE YOU PRAY FOR THOSE WHO MISTREAT YOU

LUKE 6:27-28

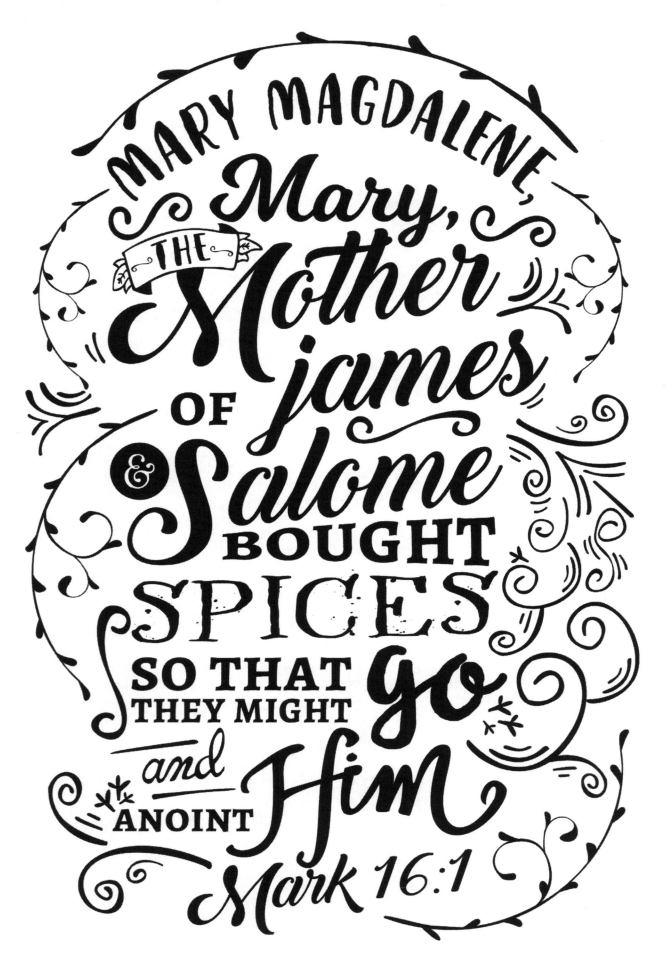

MARY MAGDALENE, Mary, THE Mother OF & James Salome BOUGHT SPICES SO THAT THEY MIGHT go and ANOINT Him Mark 16:1

Only THOSE who ACTUALLY DO THE WILL OF MY FATHER IN *Heaven* WILL enter

Matthew 7:21

Matthew 7:21

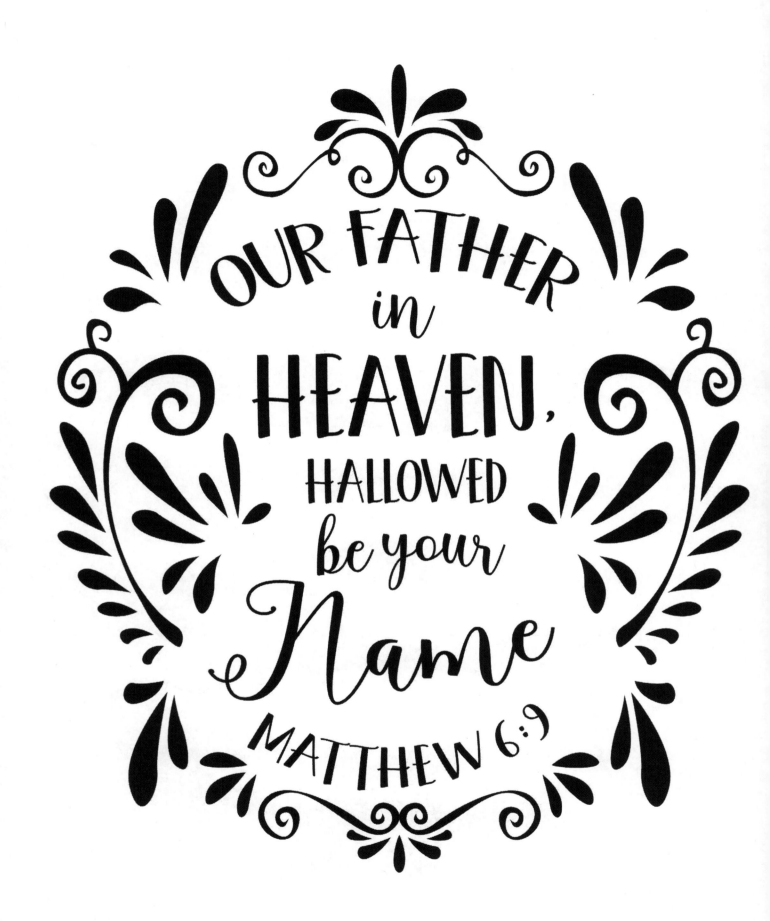

OUR FATHER in HEAVEN, HALLOWED be your Name

MATTHEW 6:9

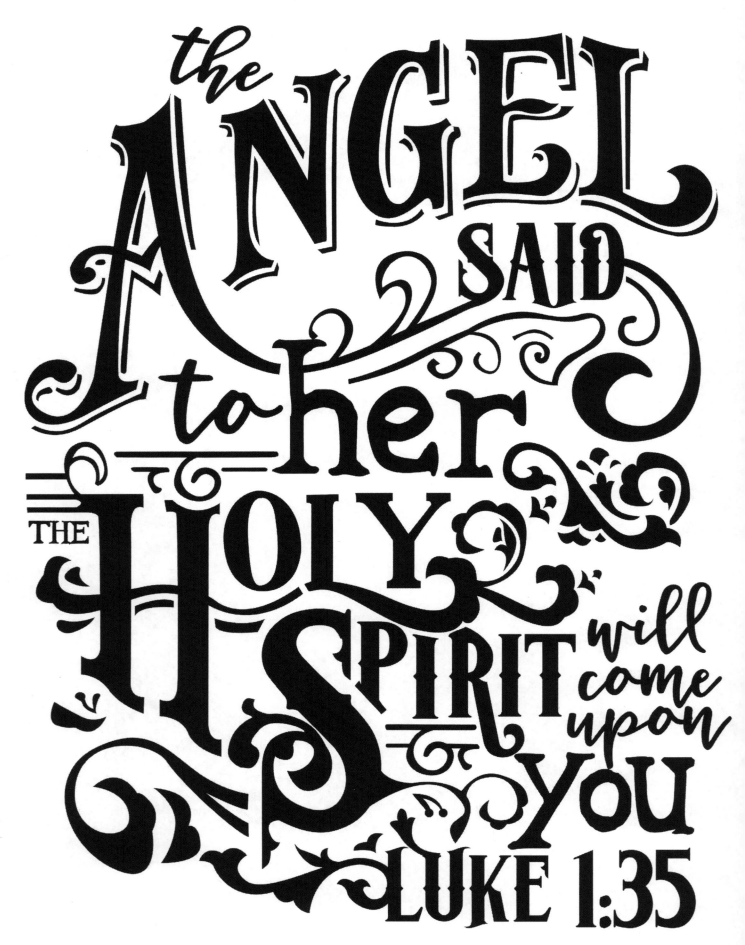

the ANGEL SAID to her HOLY SPIRIT will come upon YOU LUKE 1:35

The HEAVENS were opened and he SAW the SPIRIT of GOD DESCENDING like a dove

MATTHEW 3:16

the TRUE
LIGHT that
gives
Light
to
EVERYONE
was COMING
into the
WORLD

JOHN 1:9

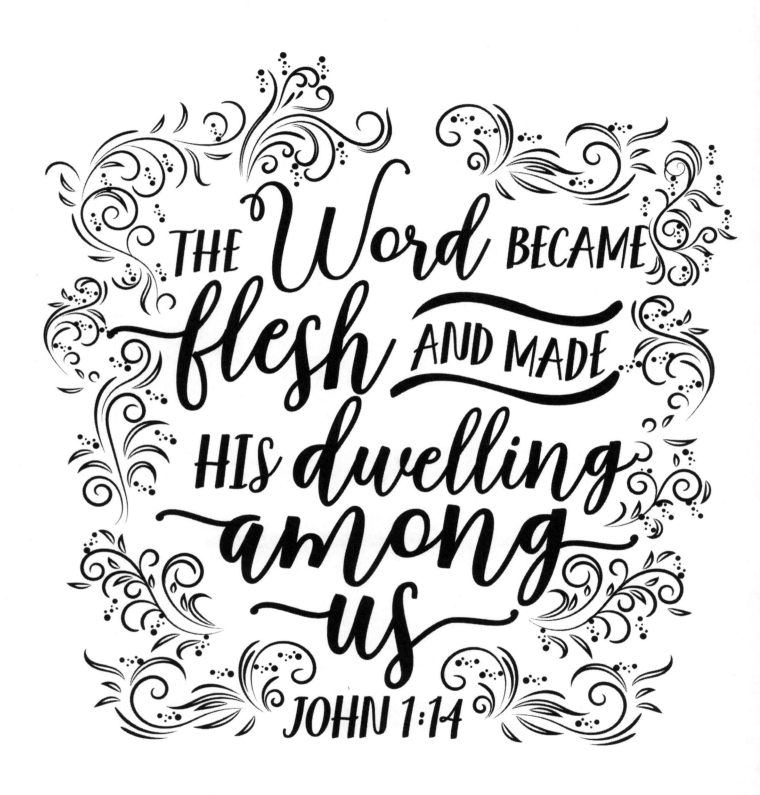

THE *Word* BECAME *flesh* AND MADE *HIS dwelling among us*

JOHN 1:14

therefore
I TELL YOU,
ALL THAT YOU
ASK for in PRAYER,
believe that YOU
will RECEIVE it &
it SHALL be
YOURS.
MARK 11:24

THIS IS MY BODY, WHICH IS GIVEN FOR YOU. DO THIS IN REMEMBRANCE OF ME

LUKE 22:19

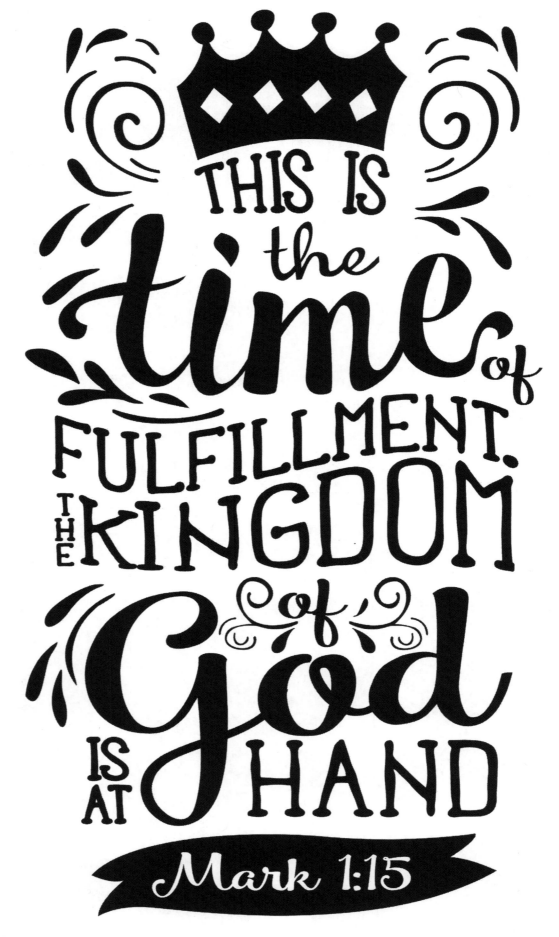

THIS IS the time of FULFILLMENT. THE KINGDOM of GOD IS AT HAND

Mark 1:15

Mark 1:15

THIS MAN welcomes SINNERS & EATS with them

LUKE 15:2

UNLESS SOMEONE IS

born again,

HE CANNOT SEE

THE Kingdom

OF GOD

John 3:3

WHOEVER BELIEVES
AND IS BAPTIZED
will be
Saved
MARK 16:16

Whoever desires
TO COME
AFTER ME
let him deny himself,
& TAKE UP
HIS Cross,
AND FOLLOW ME
MARK 8:34

With LOUD shouts they INSISTENTLY Demanded THAT HE BE CRUCIFIED

~Luke 23:23~

BE SURE TO FOLLOW US
ON SOCIAL MEDIA
FOR THE LATEST NEWS,
SNEAK PEEKS, & GIVEAWAYS

inspiredtograce

Inspired-to-Grace

@inspired2grace

ADD YOURSELF TO OUR
MONTHLY NEWSLETTER FOR FREE DIGITAL
DOWNLOADS AND DISCOUNT CODES
www.inspiredtograce.com/newsletter

CHECK OUT OUR OTHER BOOKS!

WWW.INSPIREDTOGRACE.COM

CHECK OUT OUR OTHER BOOKS!

www.inspiredtograce.com

CHECK OUT OUR OTHER BOOKS!

WWW.INSPIREDTOGRACE.COM

Made in the USA
Columbia, SC
11 April 2018